Still Life in Watercolour

This is for my
Mum and Dad.

Still Life in Watercolour

DAVID WEBB

SEARCH PRESS

First published in Great Britain 2003

Search Press Limited
Wellwood, North Farm Road,
Tunbridge Wells, Kent TN2 3DR

Reprinted 2004

ISBN 190397559 X

The Publishers and author can accept no responsibility for any consequences arising from the information, advice or instructions given in this publication.

The publishers would like to thank Winsor & Newton for supplying many of the materials used in this book.

Suppliers
If you have difficulty in obtaining any of the materials and equipment mentioned in this book, then please visit the Search Press website for details of suppliers: www.searchpress.com

Alternatively, you can write to the Publishers at the address above, for a current list of stockists, including firms who operate a mail-order service, or you can write to Winsor & Newton requesting a list of distributors.

Winsor & Newton, UK Marketing
Whitefriars Avenue, Harrow,
Middlesex, HA3 5RH

Publishers' note All the step-by-step photographs in this book feature the author, David Webb, demonstrating his watercolour painting techniques. No models have been used.

There are references to animal hair brushes in this book. It is the publishers' custom to recommend synthetic materials as substitutes for animal products wherever possible. There is now a large range of brushes available made from artificial fibres, and they are satisfactory substitutes for those made from natural fibres.

Printed in Malaysia by Times Offset (M) Sdn Bhd

I'd like to thank Sophie Kersey, Juan Hayward and Roz Dace from Search Press for their help and encouragement on this, my first book. Thanks also to Roddy Paine for his enthusiasm and ideas for the photographs.

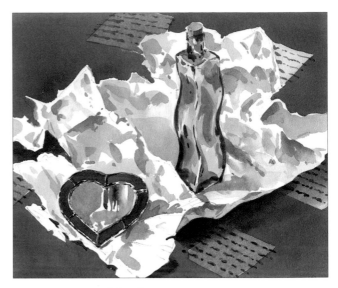

Heart Mirror and Bottle
358 x 297mm (14¹⁄₈ x 11¾in)

I was attracted to the unusual bottle shape and liked the way the green complemented the red colour in the carpet and heart-shaped mirror. I painted this one in a little more detail than usual because of the complicated patterns in the crumpled paper.

Front cover
Still Life With Yellow Pot and White Flowers
370 x 300mm (14½ x 11¾in)

It was quite a dull day when I set up these subjects. Even so, the small white flowers showed up very brightly against the background. I left the paper untouched for the white areas.

Page 2
Bookshelves
257 x 355mm (10¹⁄₈ x 14in)

If you look closely, there are a lot of reflected colours visible in the white shelves. You can also see the reflections of the books on the shiny surface.

Opposite
Daffodils
355 x 355mm (14 x 14in)

I wanted something simple for these daffodils, so I grabbed a few different jars and arranged them on a plain white surface. The green of the stems is repeated in the colour of the glass.

Contents

Introduction

I was an illustrator for over twenty years. During this time I specialised in natural history and, out of necessity, this involved painting very detailed studies.

However, in recent years I have become more interested in other subjects. I have also become absorbed in the medium of pure watercolour and now paint in a much more loose and free style. In fact, if you were to put one of my book illustrations next to one of my recent paintings, you would probably think that they were painted by two different people.

At times, I am more attracted to a certain play of light or arrangement of shapes than I am to any specific theme such as portrait, landscape or still life. My aim is to describe the scene before me, whatever it happens to be, in a way that doesn't look too laboured or overworked. It is probably my years spent drawing detailed illustrations that have led to this approach. I see it as an escape from the constraints of such work.

I love the translucency of pure watercolour and the way that you can say so much in a painting with such economy of brushwork.

My motto when painting out of doors is 'travel light, travel far'. I like to keep my equipment list to a minimum. When I am painting indoors, I use mostly the same materials. I use a fairly limited palette. The fewer colours I have, the easier it is for me to mix the shades I want. I also like to mix colours on the page and this process is made easier when you have fewer colours to worry about.

Painting still life is a challenge that provides endless material for the watercolour artist. The beauty of painting still life is the amount of control you have over every feature of your subject. The composition and arrangement of elements are wholly down to the artist, as is the lighting. However, if you are using natural light to illuminate the scene, it is important to remember that shadows will move with the sun just as they would if you were painting outside.

Another bonus is that you can paint your still life in the comfort of your own home. You can leave it set up in the corner of a room and if painting time is restricted, you can return to it at a later date.

Still life is also a great subject for beginners to painting. A simple still life arrangement is ideal for learning all the basic techniques of watercolour painting before moving on to something more complex.

The Blue Bottle
360 x 360mm (14¼ x 14¼in)
This was painted very quickly and directly, my preferred method of working. I limited myself to just one hour so that I only had time to paint an impression of the scene. This is a useful exercise which you should try.

Materials

Paints

The materials I use for my style of painting are fairly basic. I mix as many of my colours as possible, so my palette is relatively small. When I am painting in the studio, I prefer to use tube colour rather than pans, as I find it quicker to work with. My colour choice is:

Lemon yellow

Raw sienna

Cadmium red (pale)

Light red

Ultramarine

Prussian blue

Burnt umber

Rose madder hue

I find this colour choice adequate for most subjects. Every artist has his or her favourites; some use more colours, some fewer, but most will favour a couple of each of the primaries: red, blue and yellow. I find burnt umber to be a very useful brown. When mixed with Prussian blue, it makes a very pleasing dark olive colour. You will notice that my list contains no ready-made greens. I prefer to mix them myself and with the two blues in my palette, I find that I can get a wide variation.

Pigments come in two varieties: artists' and students' quality. Artists' colours are more expensive but students' quality are of a high standard these days, especially if you use a well-known brand. If you are new to watercolour painting, I recommend the students' variety. I use them frequently, especially when I am demonstrating to an art society or running a workshop. In fact, every painting in this book was painted with students' colours.

Brushes

I like to paint in a loose style, and to accomplish this I need a brush that holds a lot of water. My preference is for the squirrel mop variety. I find these ideal for covering large areas of paper and I can also achieve a fair amount of detail with them. I probably use the mop for ninety-nine percent of the painting. The other one percent is finished with a rigger for the details that are too small to be completed with the mop.

For small paintings, up to about 38 x 28cm (15 x 11in), I use a number 10 mop and a number 1 rigger. For larger paintings I have a number 15 mop for covering large areas such as skies.

Palettes

Palettes come in all shapes and sizes, and are usually made either from plastic or china. Plastic palettes are all right and, of course, they are lighter which makes them easier to carry outdoors. However, I prefer china palettes. For one thing, they tend not to stain. Some pigments are difficult to clean from the plastic variety. China palettes also feel smoother on the brush and are less hard work when you are mixing colours.

I have amassed a variety of mixing palettes over the years. I have a daisy wheel type, which has a central well surrounded by six smaller ones on the outside. The one I use most, however, is a white dish about 11cm (5in) square. I'm not sure what its original function was, but I find it ideal for mixing. Whatever you choose, make sure you get a palette with adequate mixing areas and avoid those types with dozens of wells about 1cm (½in) across!

Number 10 and number 15 mops, a number 1 rigger brush, a china palette with kitchen towel, a daisy wheel palette and a small portable paint box.

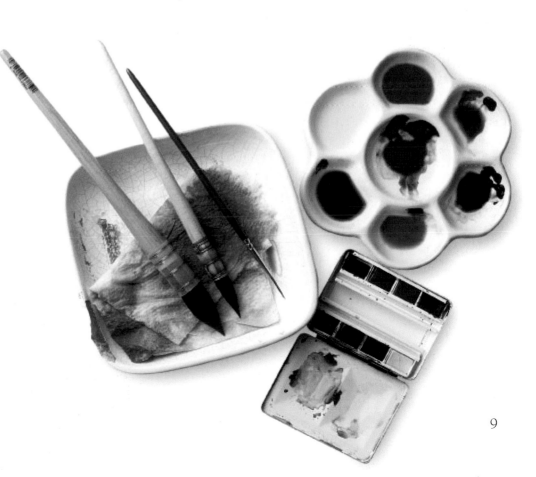

Paper

Watercolour papers come in a wide variety of weights (thicknesses) and surfaces. The weight is usually described in gsm or lb, and refers to grammes per square metre or to the weight of a ream of Imperial size sheets in pounds. The lightest papers start at around 190gsm (90lb) and the heaviest weigh in at around 850gsm (400lb).

Lighter papers need to be stretched, or they will cockle when a wash is applied. I usually use 300gsm (140lb) or 425gsm (200lb). I find that if I stick paper of these weights down to my board with masking tape, I can use it without stretching and it remains fairly flat. Any slight bumps that may occur tend to flatten out as the paper dries.

There are three types of surface in watercolour paper. Smooth (or Hot Pressed), Not (or Cold Pressed) and Rough.

Smooth is, well, smooth and is most suitable for line and wash work. Not surface has a grain, or tooth, and accepts a wash much better than a smooth surface. Rough papers have an even rougher, more textured surface than Not. I think it's fair to say that the Not surface is the most commonly used of the three, and is often referred to as a medium surface paper.

I use a Not surface paper for most of my work. Papers can be bought in sheets, pads and blocks. Blocks are like pads except for the fact they are gummed around all the edges. This prevents the page from cockling whilst you are painting. Once you have finished, the painting can be removed from the block by running a knife around the edges.

Watercolour papers vary in price, too. The best ones are handmade from cotton rags and can be quite expensive, although they are nice to work on. However, spending a fortune on the finest sheet of paper available does have its drawbacks, especially for the beginner. I have found that some students are so worried about spoiling their lovely paper that they become afraid of it! They find it hard to loosen up and their work becomes stilted. There are many reasonably priced papers and pads available, and I would advise the beginner to start with one of these until they become more confident of their skills.

*Above: Rough, Not and smooth watercolour paper and painting boards.
Below: The effects produced by painting the same apple on the different types of paper.*

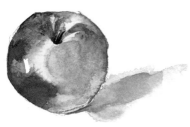

Rough paper

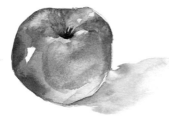

Not paper

Smooth paper

Other equipment

Boards I have a selection of different sized boards for painting. I find marine plywood to be the best. If you prefer to stretch your paper, do not use a shiny surface, as the paper tape cannot adhere properly, and will pop off the board as it dries.

Pencils As a rule, watercolour papers tend to have a soft surface and I therefore use quite a soft pencil when I am drawing my outline. I usually use a 2B or a 3B, but nothing harder than that.

Erasers I don't use erasers very much. I don't mean that I rarely make mistakes! It's just that I only use the pencil lines as a guide, and just because they are there doesn't mean I have to stick rigidly within their boundaries. After all, we are not painting by numbers. However, I appreciate that a lot of beginners like to have an eraser to hand. I recommend that you use a putty eraser as these are fairly soft and, if used carefully, they will not damage the surface of your paper.

Water jars The bigger, the better. Always use clean water when you are painting. This may seem obvious but dirty water means dirty paintings. If you have enough space, it pays to use two jars: a small one for rinsing your brush and a large one for painting and mixing. You will find that by doing this, your large jar stays cleaner for longer.

Hairdryer I often use a hairdryer to dry off my paintings between washes, particularly on damp days when the paper would otherwise take longer to dry naturally.

Craft knife I buy my paper in full imperial sheets. This way I can cut it to the shape and size I want. A sharp knife, together with a straight edge and cutting mat, is the easiest way to do this.

Masking tape I usually use a paper which is heavy enough not to need stretching. I attach it all the way round with masking tape.

Dusting brush I keep a large, soft squirrel hair brush to hand for removing objects such as bits of eraser from the paper. Since it is soft, the brush is less likely to mark the surface of the paper than, for instance, the back of your hand!

Using colour

My choice of colours is relatively small. For me, one of the joys of painting in watercolour is the mixing of pigments to make the shade I am looking for. One of the benefits of using a limited palette is that you become familiar with the colours you are using and what they are capable of. If you are new to painting, you could be forgiven for thinking that this limits the range of colours that you can achieve. In fact the combinations are almost endless.

Working methods

My method of working is fairly direct. I try to achieve the effect I want with as few washes as possible, rather than building up the painting layer by layer. I normally lay an overall wash, taking care to leave any areas that are meant to be white untouched. I then put in a secondary wash in the areas that require it, before finally adding details.

 This way of working requires confidence in one's abilities and, therefore, a lot of practice. You need to be quite confident in your colour mixing, as you may

I much prefer to mix my own greens as opposed to using ready-made versions. These combinations provide a selection of different, natural-looking greens.

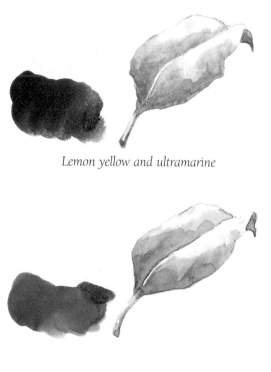

Lemon yellow and ultramarine

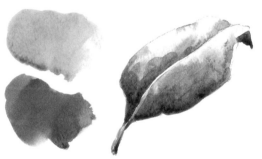

Raw sienna and Prussian blue

Lemon yellow and Prussian blue

Burnt umber and Prussian blue

have to work quickly. My washes have to be quite strong and right first time because I work directly. It's worth bearing in mind that watercolour washes look lighter once they've dried. People have often commented, when I am demonstrating, that the blue I am using for a sky, for instance, looks very dark. Later, however, when the wash has dried, it becomes apparent that the colour has lightened.

A common problem is 'muddy' colours. This usually happens when more than two are mixed together. It's tempting to try a little of everything to find the colour you want, but this often leads to a dirty puddle! I try to limit my mixes to two colours, although I may add a small amount of a third. I often mix them on the page, too. If you haven't tried this before, practise first on some scrap paper. The watercolour paintings that inspire me contain bright, clean washes featuring as few blends as possible to reach the desired result.

So, let's have a dabble. Try some of the combinations shown below on some scrap paper (or on the back of a disaster). The more practice you have at mixing colours, the more confident you will be when it comes to painting a picture. The range you can achieve with just two colours is quite surprising. Then of course, you can get further variation by adding more or less water.

When mixing a dark and a light colour together, always start with your light colour and gradually add the darker one to it until you achieve the right mix.

Different shades produced by mixing two colours.

Light red and ultramarine

Burnt umber and ultramarine

Lemon yellow and rose madder

Ultramarine and rose madder

13

Techniques

There are a number of different techniques and brushstrokes that you can use in watercolour painting. I've described a few of the most common ones below. As you progress and become more confident, you will learn more skills by reading about other artists and their methods, and studying their paintings. However, if you learn the ones I have described, it will give you a good start.

Basic wash

The basic watercolour wash is probably the first technique that newcomers to watercolour should familiarise themselves with. Before you try anything fancy, learn this and learn it well: take a brush loaded with colour. Paint a single stroke across the page. Your board should be slightly angled so that the paint runs downwards. Refill your brush and then repeat the action at the base of the last stroke, picking up the water that has collected there. Repeat the process a few times until you are confident.

Variegated wash

This is a similar technique to the basic wash. However, with the variegated wash we add different colours as we go. The important thing is to have your colours mixed up before you start, or the paint that you've already applied will dry whilst you're mixing the next one. For this exercise I used the ultramarine from before, but along the way I added a few strokes of rose madder and then lemon yellow. As you can see, this is a useful technique for use in painting skies.

Dry brush

As the title suggests, this particular brushstroke is made with less water. Get some paint on your brush and then soak up some of the excess on to a sheet of kitchen towel. The dry brush technique is achieved by quick strokes across the page, so that the brush scrapes over the surface of the paper leaving a sort of 'hit and miss' effect. It requires some practice to get this right, so use plenty of scrap paper.

Wet in wet

This technique involves allowing colours to merge on the page. The paper can be wetted first and then colour can be dropped in, creating soft edges. Alternatively you can apply one colour to a dry surface, and then paint another colour alongside it, allowing the two colours to blend when they come into contact. I use the wet in wet technique a lot. Take a look at the paintings in this book and you will see where I have applied it. It's exciting to paint this way, although you may find that you are only about seventy-five percent in control of your painting!

Cadium red (pale), lemon yellow and ultramarine are the only colours needed for this exercise.

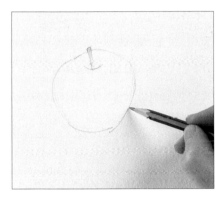

1. Draw the basic outline of the apple using a 1B pencil. This will be easy to see but will not scratch the surface of the paper.

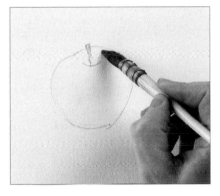

2. Dip the squirrel mop brush in clean water and wet the area of the apple, being careful to leave untouched those parts that will show as highlights.

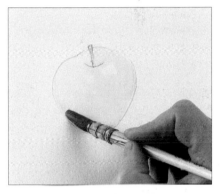

3. Load the brush with lemon yellow and drop the colour into the right-hand side, avoiding the parts that will be red. Over-run the bottom left-hand edge slightly to suggest reflected light in the shadow.

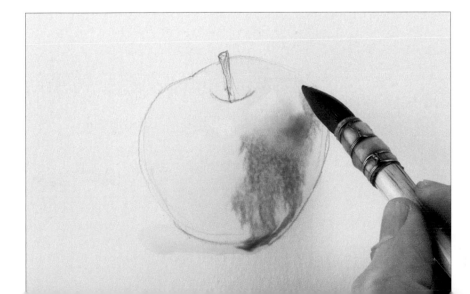

4. Add ultramarine to the yellow and move it around, mixing the two colours to make green.

15

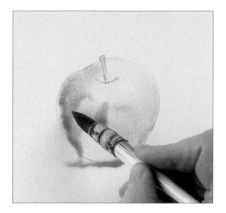 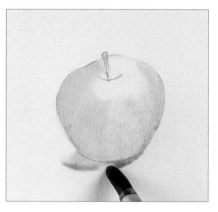 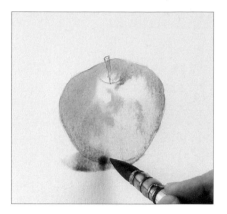

5. Drop in cadmium red (pale), being careful to avoid the highlight areas. Dry the brush on a sheet of kitchen towel and touch the tip of the brush to any pools of excess paint. The brush will soak up the surplus colour.

6. Add more ultramarine to the green side of the apple. Once again, soak up the wet paint at the bottom with a dry brush.

7. Add ultramarine to the bottom left-hand side of the apple for shadow.

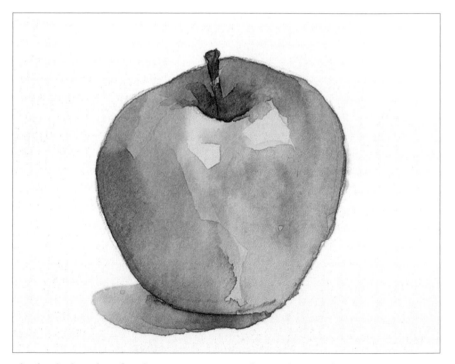

The finished apple. After the wet in wet stages shown above, I allowed the painting to dry. I then finished off, working wet on dry. This allows more control and creates harder edges. I used burnt umber for the stalk and the area of shadow around it. I mixed red and ultramarine for the shadow on the left-hand side, plus some ultramarine and lemon yellow for more green in the middle. Ultramarine and burnt umber were used to finish off the stalk area.

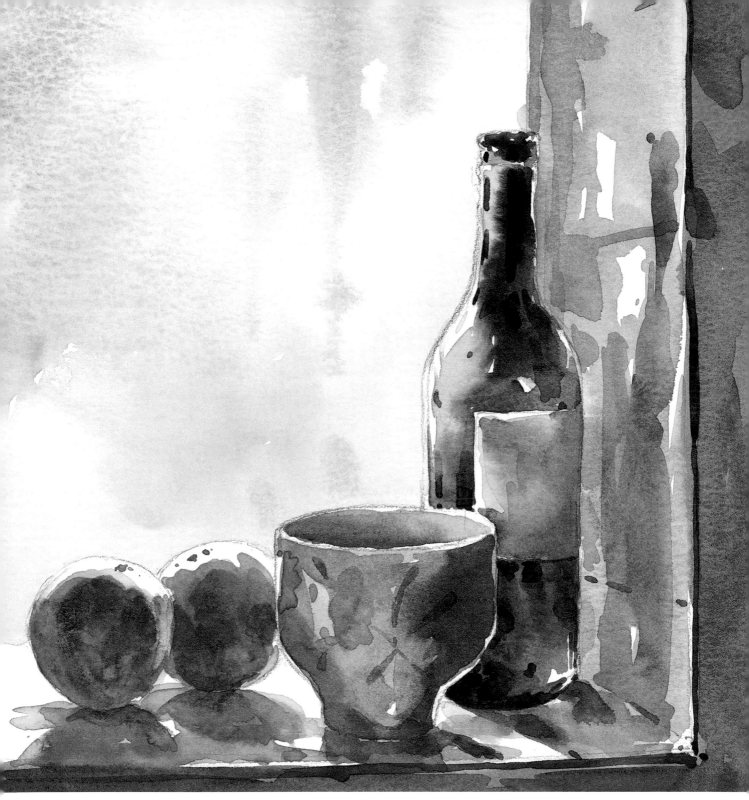

The Kitchen Window Ledge

250 x 250mm (9¾ x 9¾in)

This painting clearly shows areas where I have used the wet in wet technique, particularly in the light area of the window, the bottle and the bowl. I also mixed some of the colours on the page. I am often drawn to backlit subjects like this – they provide dramatic and interesting effects.

Light and shade

When painting, I am always aware of the direction of the light source, and whether the light is soft or harsh. Are the shadows hard-edged or diffuse? Are they warm or cool in tone? These are important considerations when painting any subject, but they become even more apparent in still life. Setting up a simple arrangement of objects gives you the ideal opportunity to study light and shade.

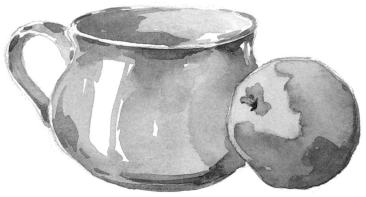

Soup mug and orange

Colour in shadows

Some beginners assume that any dark mixture will do for 'shadow colour'. However, this makes for dead-looking paintings. Take a look at these watercolour sketches. Look at the areas of shadow. If you place a brightly coloured object such as an orange next to a pale object, you can see some of the orange colour repeated in parts of the shadow area. This is known as 'reflected light' and occurs when a brightly lit surface throws light into a shadowy area. If you make a habit of creating little sketches like these in watercolour, you will soon become aware of the importance of shadows and your paintings will have a sense of atmosphere.

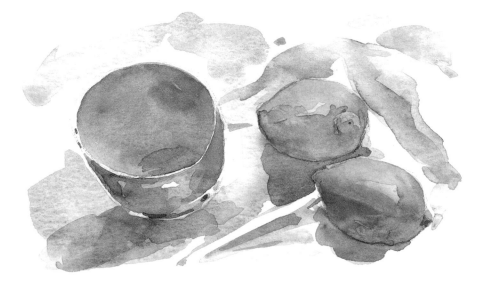

Bowl and lemons

Monotone painting

People often take great pains to match a colour exactly, but can be less concerned about getting the tones correct. This, however, is more important in my view. Tones give a painting depth. When you look at a black and white photograph, different tones are obvious. However, when you are painting a scene before you, it can sometimes be difficult to tell the difference in tone between two different coloured objects. A good exercise is to do a painting in monotone, i.e. all in one colour. Set up a still life arrangement and then mix up a single colour to paint the whole scene. This trains you to assess different tones. Use the white of your paper to depict highlights, and undiluted colour for the darkest tones. Add varying amounts of water to dilute the colour for the tones in between. Look hard at the objects in front of you and try to judge the tones, rather than the colours, as accurately as you can.

This small monotone study was painted using only sepia.

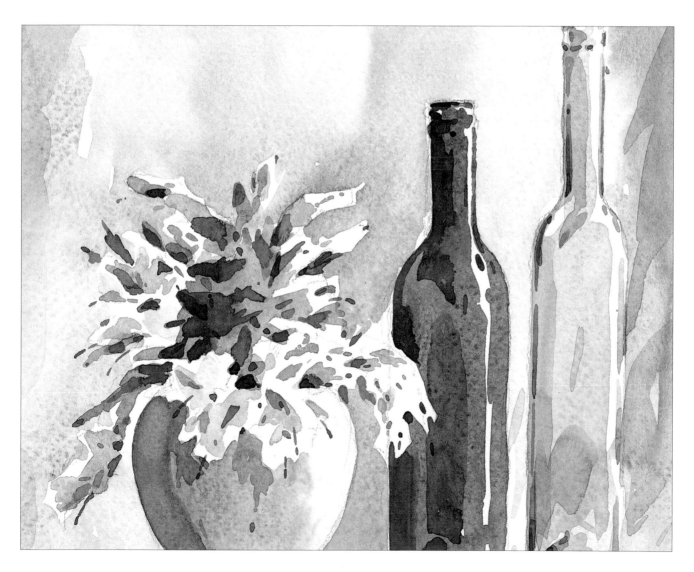

Counterchange

Put simply, counterchange is the placing of dark elements next to light ones (and vice versa), to create drama and interest within a painting. One example of this would be a white sail against a dark, stormy sky. We can use this in still life painting, too. Sometimes we can create the shape of an object simply by painting the area around it. This is often referred to as painting the negative shape. By placing light and dark areas alongside each other, we can link elements of the painting together.

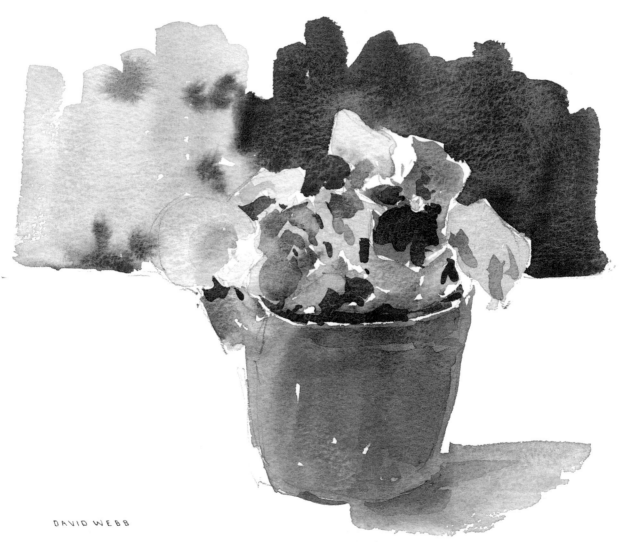

DAVID WEBB

You can see clearly in this small watercolour sketch where I have used counterchange. The flowerpot itself contrasts with the white surface it is resting on, and the light-coloured leaves on the right are in great contrast to the dark background. As the leaves on the left are roughly the same tone as the background, I have 'lost' the edges by letting the colours blend on the page.

Lost and found

It is quite common for beginners to put a line, or edge, around every item in their painting. I know because I used to do it! Your brain tells you that a solid object must have an edge, so why not put it in? However, if you do put an outline around every component of your painting, it will look as if they have been cut out and pasted on. To avoid this, we use what is known as the 'lost and found' effect. If you have two objects of similar tone next to each other, it can often be difficult to see a definite edge. When this occurs it is quite all right to 'lose' those edges and blend the two together. The 'found' areas are the parts of obvious contrast.

By including 'lost and found' sections in a painting, you provide some mystery for the viewer: something is left to the imagination. To illustrate this point I have made two small paintings of the same subject. In the first one, I painted all the edges around the objects. You can see how stilted and boring it looks. In the second painting, I made use of the 'lost and found' effect. You can see what a difference this makes and how the elements seem connected to each other.

Composition

The arrangement of elements in a painting can make the difference between one that is boring to look at and one which grabs our attention. In still life painting we have complete control over composition. I find that it often helps to make a series of arrangements and make small sketches of these until I find an idea that interests me. By studying the work of other artists, you can learn a lot about how they compose a picture. Sometimes the simplest arrangements are the most effective.

In the following series of compositional studies, I have taken four items and placed them in different arrangements. It is a good exercise to make small paintings like these before settling on a composition you are happy with. However, it is possible to get so carried away with arranging your piece that you run out of time in which to paint it!

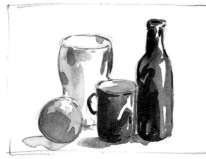

This arrangement is quite formal and rigid, and not very interesting to look at.

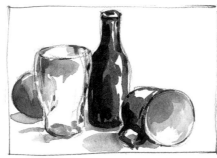

By turning the mug on to its side, we have broken the rigid framework of the arrangement. However the items are still mostly bunched together.

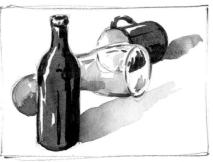

This time the objects are arranged with a little distance between them. Some drama is created by the diagonal composition. The direction of the shadows also adds interest.

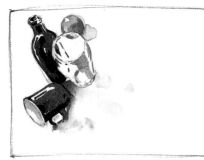

Here we have a different viewpoint: looking down on to the arangement, with the shadows pointing into the open space.

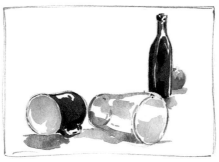

In this sketch the mug and the jar are lying on their sides, and the bottle and orange are some distance away.

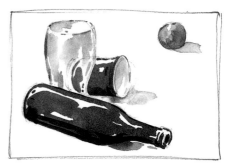

In this final composition the orange is positioned away from the rest of the objects.

Still Life with Walnuts and Onion
297 x 393mm (11¾ x 15½in)

I selected this group of items from the kitchen. After trying out various ideas for composition, I settled for this one. I liked the muted colours of the objects, but I chose to place the bright blue mug on its side, with the walnuts spilling out, to provide a bit of drama.

DAVID WEBB

Drawing

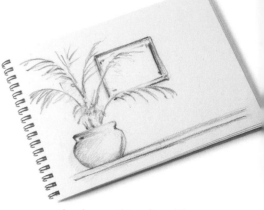

If you are serious about painting, then you should also strive to improve your drawing skills. A good drawing is the backbone of a good painting. You should sketch whenever time allows. A small pad and a pencil are all you need. The point of a sketchbook is not to produce masterpieces, but to improve your observation and measurement skills. Sketching trains your eye to see what is relevant and what is unnecessary clutter.

Time can always be made to practise drawing. A lot can be achieved, even if you only have five minutes to spare. We seem to spend a lot of time these days just waiting. Waiting for trains, waiting for buses or even just waiting for our favourite television show to start. Just think how much drawing you could do in that time! If you make a point of drawing something from life every day, you will soon see your work improve. Don't just draw things that you are good at, either. Your problem subjects should be the things you practise the most.

Sketch something from life every day to improve your drawing skills.

Ellipses

Many people find it difficult to draw ellipses. Objects such as cups, vases and plates often present problems. Try to achieve these shapes in one sweeping action, using your whole arm as opposed to resting your forearm on the paper and simply using your wrist. You'll find that you get a much smoother, more rounded shape if you work this way. Place an object such as a mug in front of you. Sketch it from different angles and levels.

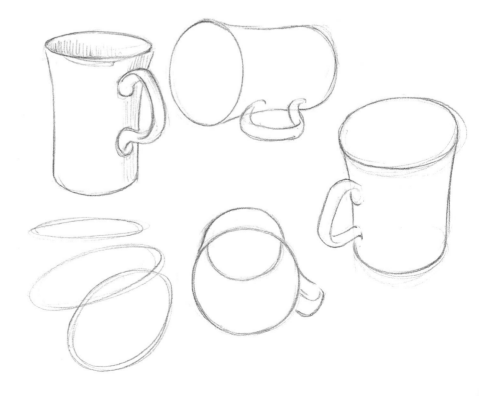

24

Measuring

Drawing your subjects in proportion to each other is a skill which requires careful observation. However, with practice you will quickly improve.

If you have a group of objects in front of you, choose one as your standard measurement. For instance, in this simple arrangement you can see that the orange on the far left is about one 'orange width' from the bowl. The bowl itself is roughly one and a half times the width of the orange. The bottle is about as wide as the orange and four times as high.

Angles are important, too. If you were to draw a line between the same orange and the top of the bottle, you can see that this line would be about forty-five degrees to the horizontal.

When I am drawing, I am constantly aware of these relative distances and angles. No matter what your subject is, if you observe these distances then your drawing should be fairly accurate.

Tonal drawings

It can often be useful to make a tonal sketch of your subject before committing paint to paper. By using your pencil as a shading tool, you can establish the tones of your painting before you start. This type of sketch doesn't necessarily have to be the same size as your final painting. I often make small tonal drawings, which I find quite useful. Try not to make them too detailed – they are only intended as a guide to help you judge your lights and darks and the shades in between.

Apples on a Plate

I usually prefer to paint using a direct method. However, for the purposes of these step-by-step exercises, I have built up the paintings in a series of washes. For this first demonstration I chose to paint a simple composition. Take a moment to study the arrangement before you start drawing. Remember how important it is to get the proportions right, as described on page 25. Once you have drawn the outline, look at the way the light falls on to the arrangement and where the shadows are.

In still life the arrangement of elements in your composition and the direction of the light are up to you. For this simple scene I placed two apples on a plate. I cut one in half for a bit of variation and then arranged the whole apple and pieces, along with the knife.

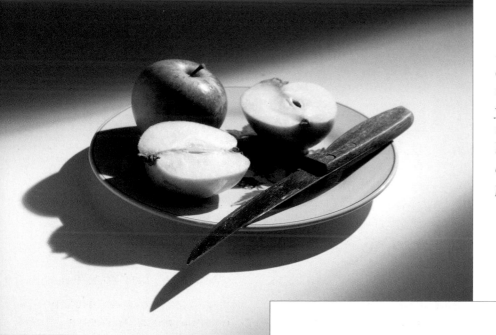

1. Sketch the general outline of the scene. Do not include too much detail, but make sure you get the ellipse right for the plate.

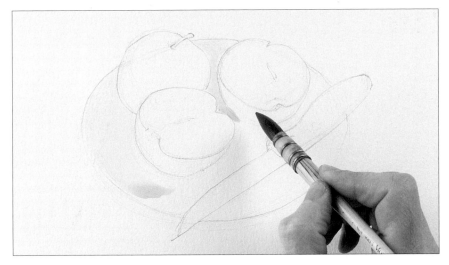

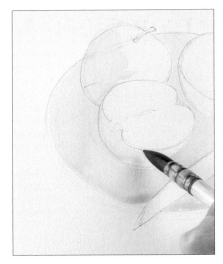

2. Apply a weak wash of light red and ultramarine over the plate and some of the apple. Avoid the areas that will be highlighted.

3. Working wet in wet, paint a green wash using lemon yellow mixed with ultramarine.

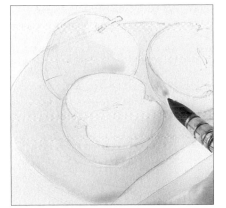

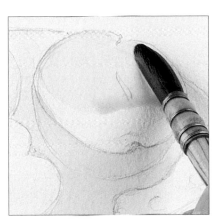

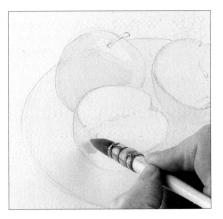

4. Drop some light red into the red areas of the right-hand apple to create a warmer wash, once again avoiding the highlight areas. Allow this to dry.

5. Add just a little light red to lemon yellow to make a light wash for the cut surfaces of the apples. Soak up any excess water with a dry brush.

6. Paint a stronger wash of lemon yellow on to the apple skins.

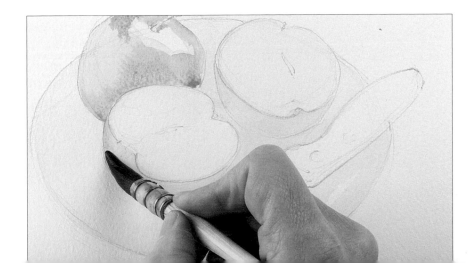

7. Add light red to the wet yellow colour.

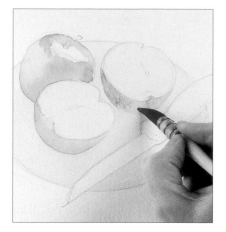

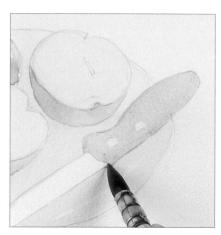

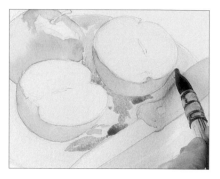

8. Add blue for the shadow at the base of the left-hand cut apple. Wash red on to the right-hand cut apple, then add blue for the shadow at the base.

9. Paint a light wash of burnt umber over the knife handle, leaving white circles for the rivets. While still wet, add some ultramarine to the underside for shadow.

10. Mix an overall wash from ultramarine and light red for the plate. Work in some green mixed from ultramarine and lemon yellow to hint at the leaf pattern. On the far right, paint reflected colour from the apple using lemon yellow and ultramarine.

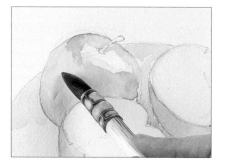

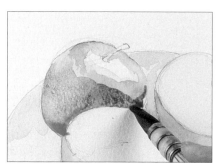

11. Paint a strong yellow on to the left-hand side of the apple on the left.

12. While this is still wet, add ultramarine to the yellow to create a strong green, and some light red to the right-hand side.

13. Paint the apples' shadows, dropping in light red and ultramarine wet in wet. Mix green for the reflected colour of the apples.

14. Paint the shadow around the plate using ultramarine and light red. Drop in the reflected colours you see in the shadow: more ultramarine on the left and for the shadow of the knife. Add light red towards the right where the light is coming from, since the shadow is warmer here.

28

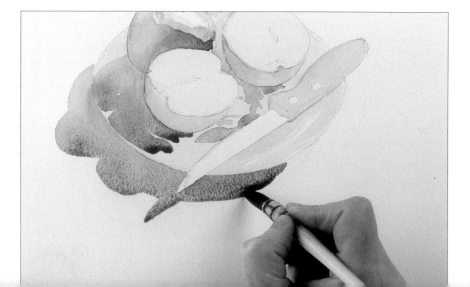

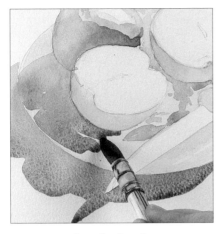

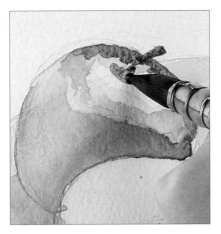

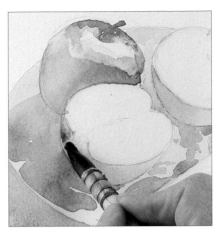

15. Use a brush dried on kitchen towel to gather up any drips of paint. This avoids the 'cauliflower' effect of wet paint spreading into dry.

16. Soften any hard edges on the whole apple using a damp brush. Add an edge of light red to the top. Add ultramarine to this to paint the stalk and the little hollow around it.

17. Mix light red and a little ultramarine for the edge of the foreground apple.

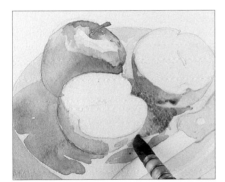

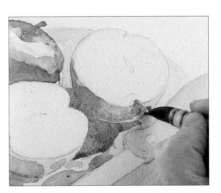

18. Add light red to the right-hand apple, and drop in some ultramarine to create the shadow beneath it.

19. Mix green for the stalk hollow of the right-hand apple.

20. Mix burnt umber and ultramarine for the shadow at the top of the knife handle and the dark shadow where the handle meets the blade.

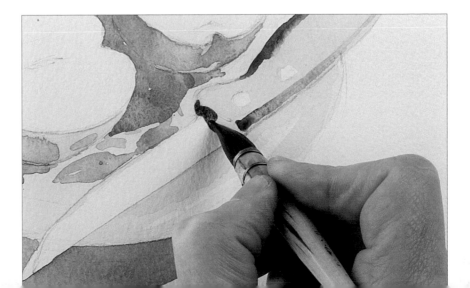

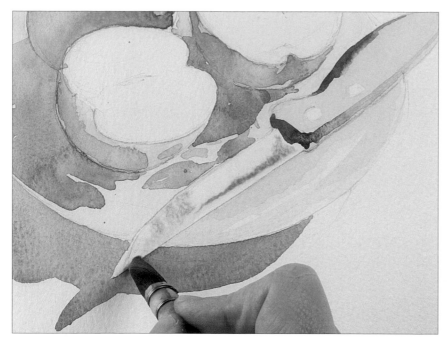

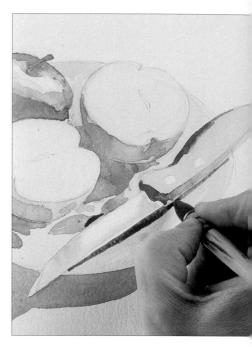

21. Brush clean water over the knife blade, then drop in ultramarine and burnt umber.

22. Paint a shadow around the knife using light red and ultramarine.

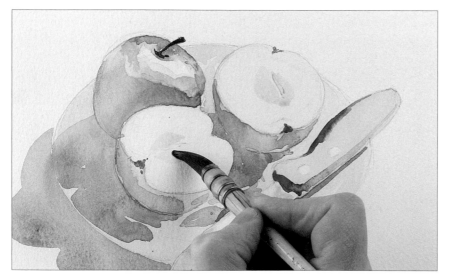

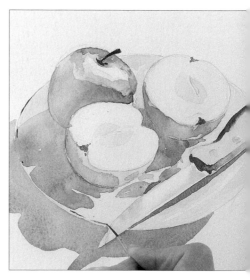

23. Mix ultramarine and burnt umber for the shadow in the stalk of the whole apple. Use burnt umber to add the suggestion of a stalk in the apple halves. Add ultramarine to lemon yellow for the pale green shapes in the core areas of the cut apple halves.

24. Paint in the knife rivets with lemon yellow and burnt umber. Using a rigger brush, mix light red and ultramarine to paint the shadow at the rim of the plate.

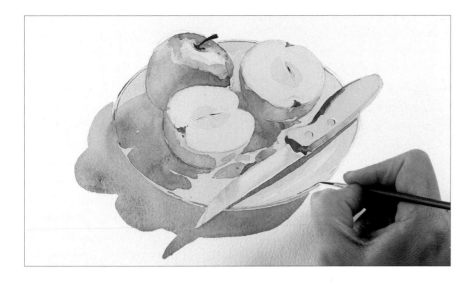

25. Use the rigger to suggest the shadows around the rivets, with ultramarine and burnt umber. Pick out the details of the apple pips, and finally paint the green line around the edge of the plate.

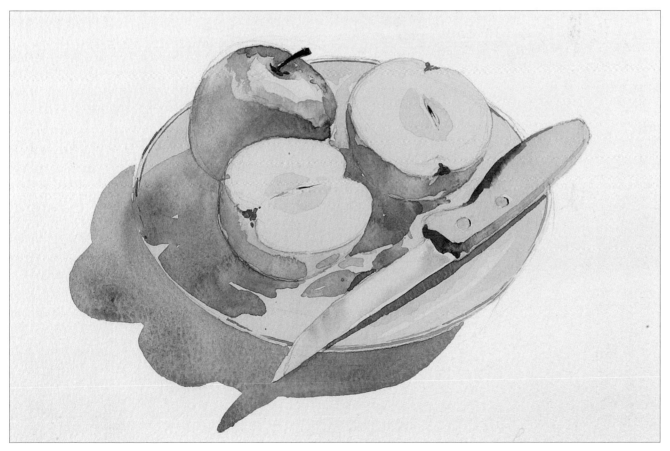

The finished painting
220 x 160mm (8¾ x 6¼in)

A simple subject like this is ideal for studying the effects of light. It contains cool blue shadows and areas of warmer reflected colour. Just think how lifeless it would have looked if we had painted an overall, bland grey for the shadows.

Glass With Cherries

370 x 270mm (14½ x 10⅝in)

This painting was carried out very quickly. I allowed the edges of the cherries to merge with each other here and there. The highlights on the glass are echoed in the glossy surfaces of the cherries, and their reflected colours are also evident in the shadows.

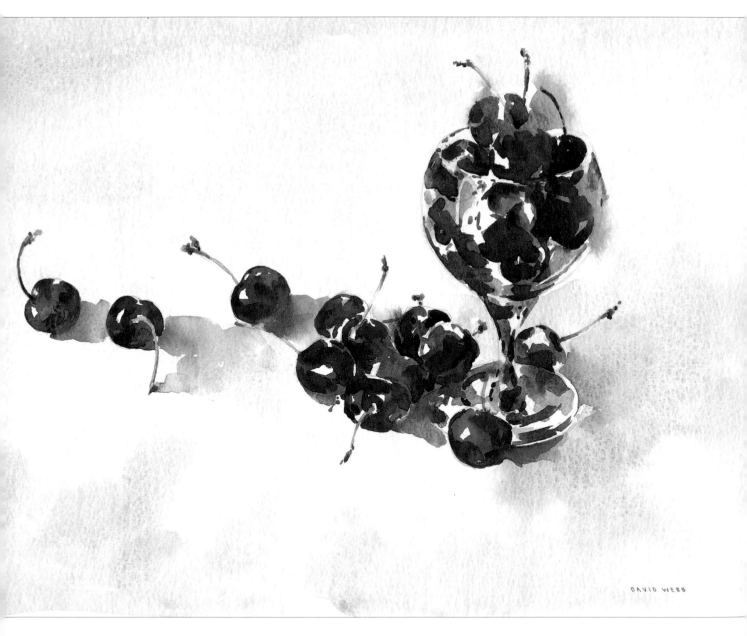

DAVID WEBB

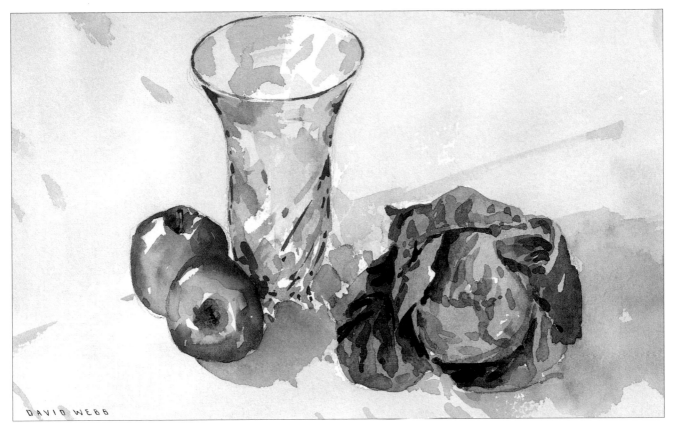

Glass Vase with Apples and Cabbage
220 x 140mm (8⅝ x 5½in)

With its spiral pattern and green colour, this small, delicate glass vase was an enjoyable subject to paint. I chose the little cabbage for its repetition of the green, and the red of the apples is complementary.

Plums in Brown Paper

It can be a challenge to depict an object, or group of objects, in close-up. When you look at everyday items closely, they can provide interesting abstract shapes. Viewed from unusual angles, the mundane can be transformed into fascinating patterns. By adding a low-angled light source, the shadows, too, can become part of the pattern.

For this demonstration I chose to paint a close-up view of some plums. I was attracted to their deep, blue-back colour and the contrasting light bloom on their surfaces. I added the golden yellow plum to introduce some warmth. I wanted to paint the arrangement as viewed from above. I originally placed the fruit in a plastic box, but this wasn't particularly attractive, so I lined it with a piece of scrunched up brown paper, which then provided me with some interesting shapes and shadows.

You will need
300gsm/140lb Not paper
3B pencil
Colours: rose madder, ultramarine, lemon yellow and burnt umber
Squirrel mop and rigger brushes
Kitchen towel

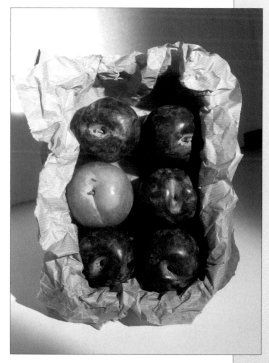

I chose this subject for the demonstration as it is relatively easy to draw. It also allows you to practise washes and some wet in wet techniques. The box was lit from the right.

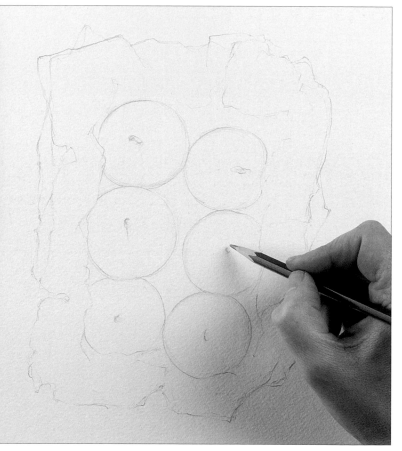

1. Use a soft pencil to sketch the basic outlines of the scene, without using too much detail. Do not attempt any shading. Be aware of the negative shapes between objects as well as the objects themselves.

34

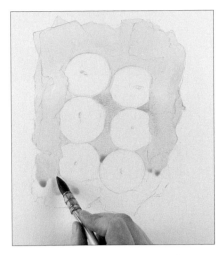

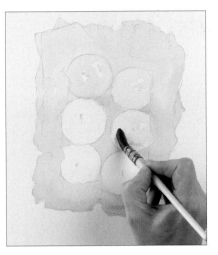

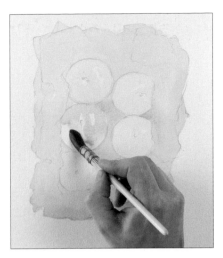

2. Wash clean water over the area of the brown paper. While this is wet, drop in some burnt umber and raw sienna and allow them to mix on the page.

3. Apply a light blue wash for the blue plums, leaving the highlighted areas unpainted.

4. Mix lemon yellow with a little rose madder for the yellow plum wash. Add a touch of pale blue for the bloom in the centre.

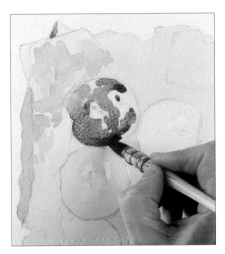

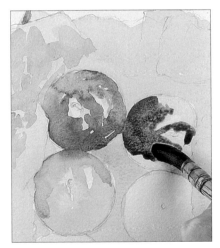

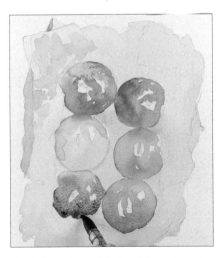

5. Add a stronger mix of burnt umber to paint the basic shadows on the brown paper. Do not attempt to add details of creases at this stage. While the brown is wet, add blue to the top left plum for the bluer areas, and then rose madder for the redder areas. Allow the colours to run together on the page.

6. Add a weak mix of rose madder and a little ultramarine to the top half of the yellow plum. Wash a stronger mix of ultramarine and rose madder into the plum at the top right, as you did with the one on the left.

7. Paint the middle right plum in the same way, adding a yellow reflection on the left from the yellow plum. Paint the bottom right-hand plum with darker shades for a shadow at the bottom. Soak up excess paint with a dried brush. Paint the plum at the bottom left in the same way, with a yellow reflection at the top. Allow to dry.

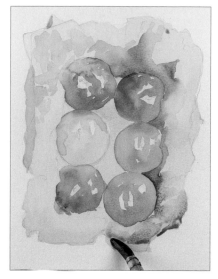

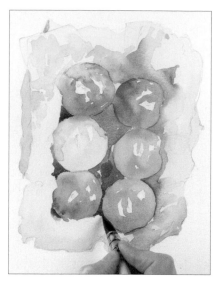

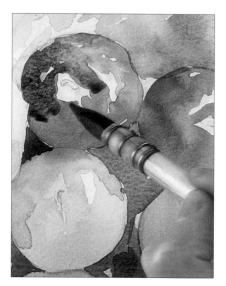

8. Add shadows to the brown paper using burnt umber. Add ultramarine and rose madder for reflected colour from the plums.

9. Make the shadows stronger around the plums to show the depth of the box and the shape of the fruit.

10. Add blue mixed with rose madder for the shadows on the top left-hand plum. Soften the edges with a wet brush.

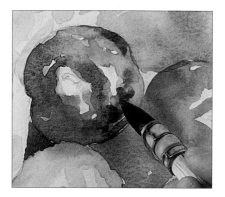

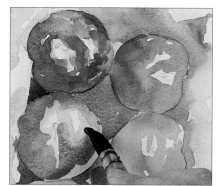

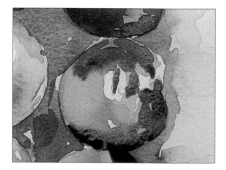

11. Add dabs of rose madder to the top left-hand plum.

12. Mix lemon yellow and rose madder, and paint the yellow plum. Allow to dry.

13. Use ultramarine mixed with rose madder for the shadow on the top right-hand plum.

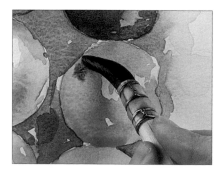

14. Brush clean water on to the middle right-hand plum. Drop in lemon yellow for the reflection from the yellow plum. Then add a little rose madder.

15. Add deep blue shadow at the bottom and soften the edges with water.

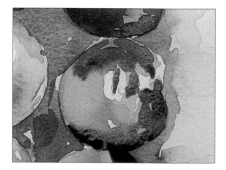

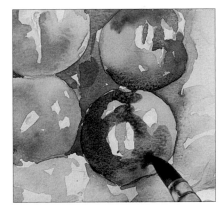

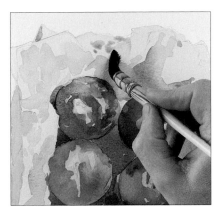

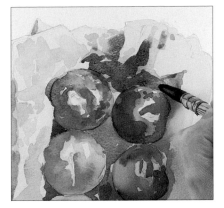

16. Mix ultramarine and rose madder for some deep purple shadow on the bottom right-hand plum.

17. Add more shadows to the brown paper using burnt umber with rose madder. Dilute the colour for the shadows at the top.

18. Create a darker mix using burnt umber and ultramarine for the deeper shadows at the top near the plums.

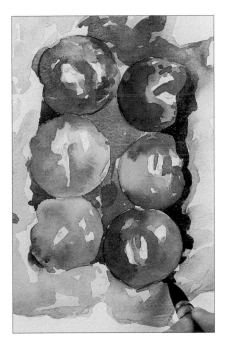

19. Paint the deep shadows to the right of the plums. Allow the shadows to follow the contours of the plums to give them form. Use varying combinations of burnt umber, ultramarine and rose madder.

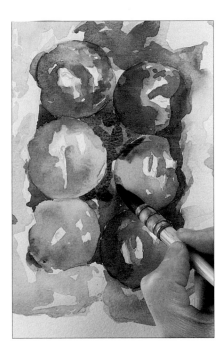

20. Use ultramarine and rose madder for the central shadows on the paper and the plums.

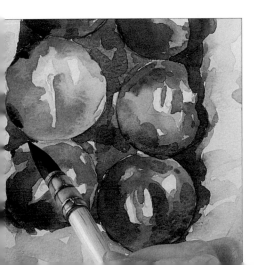

21. Mix ultramarine and rose madder for more shadows on the darker plums. Use lemon yellow and rose madder for the warm orange reflection on the bottom left-hand plum. Paint a shadow on the yellow plum with burnt umber.

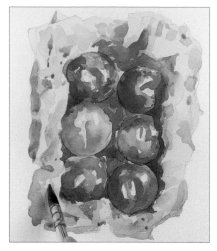 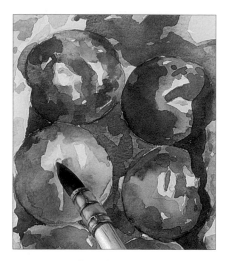

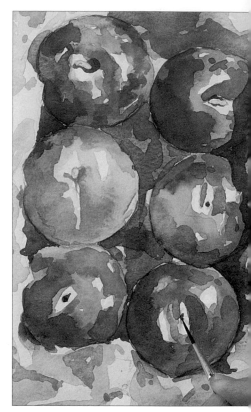

22. Add some details in the shadows on the brown paper using burnt umber and ultramarine. Use more ultramarine for the cooler shadows on the bottom left. Allow to dry.

23. Paint the plum stalks using rose madder mixed with yellow.

24. Change to a rigger brush and paint the shadows round the stalks using a mix of ultramarine and rose madder.

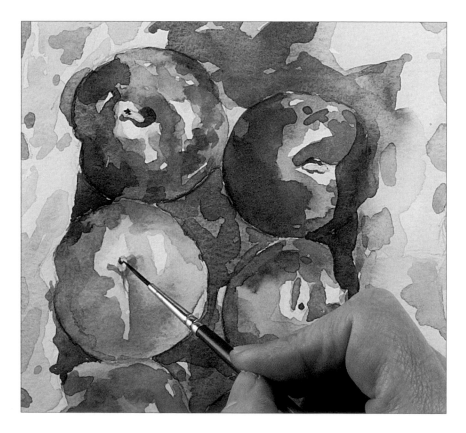

25. Use the rigger for any final details. Use rose madder and lemon yellow to make orange for the details on the yellow plum. Use varying combinations of rose madder, ultramarine and burnt umber for the plum stalks.

Opposite
The finished painting
185 x 235mm (7¼ x 9¼in)

The colourful fruits make an attractive subject. The warm reflections from the yellow plum are quite apparent in the darker, purple plums. Using clean, transparent washes gives the painting a luminous quality. Notice how we can still see the initial washes showing through in the lighter parts of the painting. If you resist the urge to overwork and add too much detail, the final result has a freshness about it.

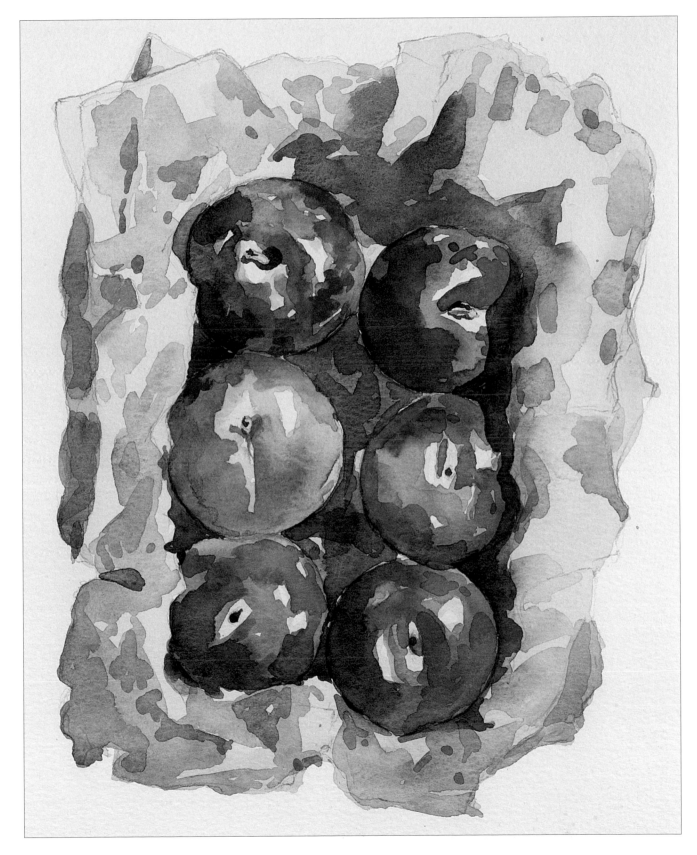

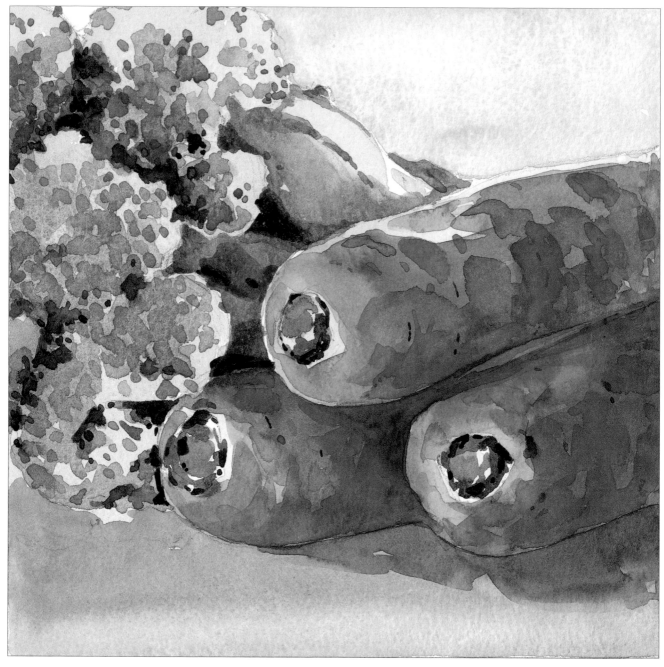

Carrots and Broccoli
203 x 203mm (8 x 8in)

Here is another close-up view of some everyday items. I resisted the urge to put too much detail into the florets of the broccoli and concentrated instead on their overall shape and the contrast between the areas of light and shade.

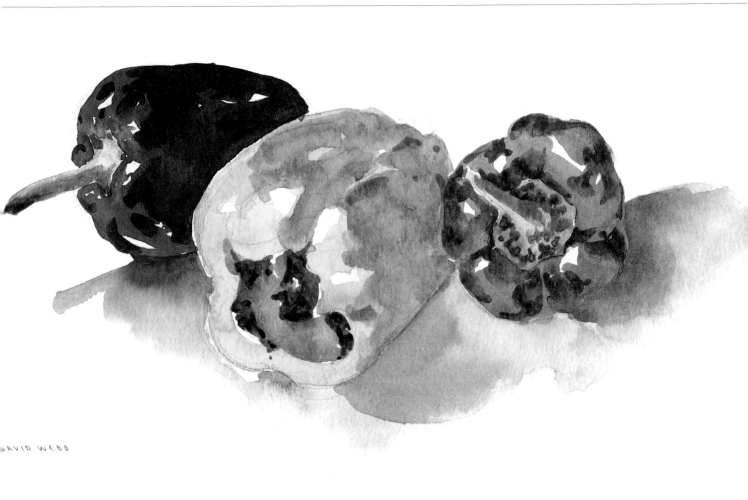

Peppers
340 x 230mm (13½ x 9in)

These three peppers were wrapped together and seemed to leap out from the shop window! I used the white, untouched paper to describe the shiny highlights on their surfaces. The dark red pepper contrasts very strongly with the much lighter yellow one. The yellow pepper also clearly shows some reflected colour from the green one.

Still Life With Glass

Glass and other reflective surfaces have always held a special fascination for me. I find that bottles, jars and coloured glass make very appealing subjects for painting in watercolour. Positioned against a window, backlit with light shining through or placed in the path of a shaft of sunlight, even a humble jam jar becomes a thing of beauty. Before you start, take a look at your set-up and be aware of the direction of the light souce and the position of the highlights and reflections.

You will need

300gsm (140lb) Not paper

3B pencil

Colours: ultramarine, burnt umber, light red, lemon yellow and Prussian blue

Squirrel mop and rigger brushes

Kitchen towel

Hairdryer

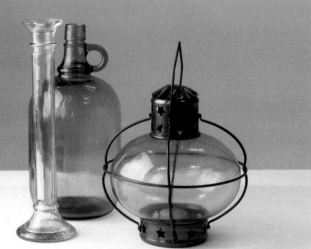

I chose these three items for their variety of colour and shapes. I liked the deep green of the cider bottle (found in the loft). The glass candlestick was spotted in a charity shop, which are always a good source of material for still life objects. I was drawn to the lamp because of its domed glass and the wire frame around it.

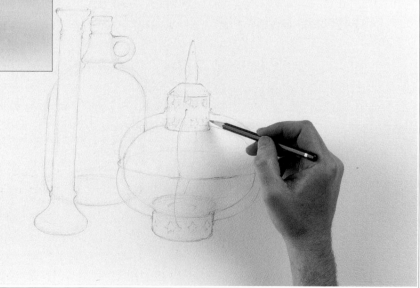

1. Draw the basic outline of the scene. It may help to sketch the outline faintly until you are sure of your lines, and then go over it with a heavier line. Draw the set-up slightly off-centre on the paper to allow for shadows falling from left to right.

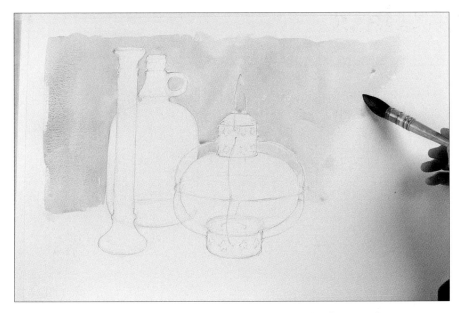

2. Paint a light wash from left to right across the background, using ultramarine and a little burnt umber. Gradually wash in a mixture of ultramarine and light red towards the right-hand side where the light is warmer.

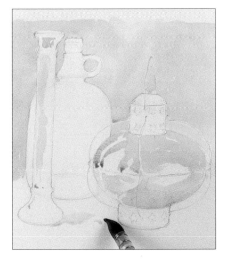

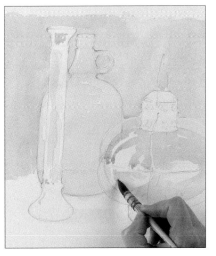

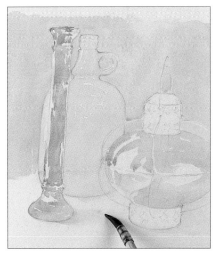

3. Paint the areas of glass on the candlestick and lamp where the background shows through. Leave areas untouched for the reflections. Use the warmer pink wash for the shadow of the candlestick.

4. For the green bottle, carefully add Prussian blue to lemon yellow. Add a little at a time as this is a very strong colour. Again, leave any highlights untouched. Paint the areas within the candlestick and lamp where the green shows through.

5. For the candlestick, add ultramarine to lemon yellow on the page, mixing the colours wet in wet. Add a small amount of Prussian blue here and there. Allow the wash to run into the shadow of the candlestick.

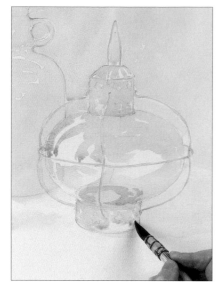

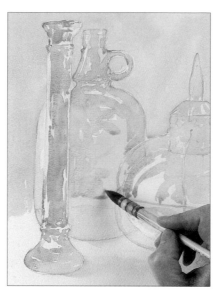

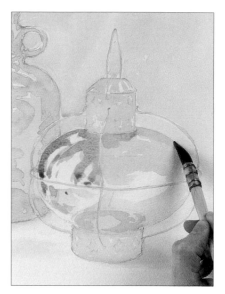

6. Wash over the metal parts of the lamp with a mix of light red and burnt umber. Leave the highlights unpainted.

7. Add a darker green wash to the bottle, this time with a little more Prussian blue added to the lemon yellow.

8. Add burnt umber to ultramarine for a stronger wash on the glass of the lamp. Pick out the reflections in more detail, for instance from the wire, and the darker shades on the outside to give shape. Allow to dry.

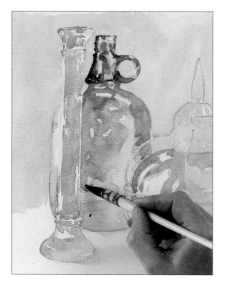

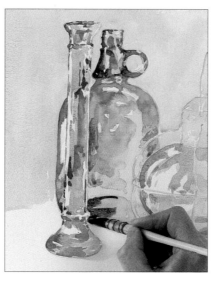

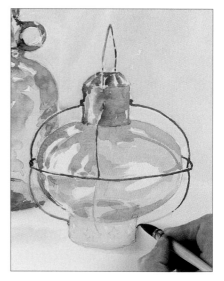

9. Mix ultramarine and burnt umber for the darkest tones on the neck of the green bottle, and paint some darker areas of the bottle with ultramarine and lemon yellow.

10. Apply a darker wash to the candlestick where it reflects the green bottle. Build up the darks on the lower part of the green bottle.

11. Mix burnt umber and ultramarine for the darkest tones of the lamp metal.

44

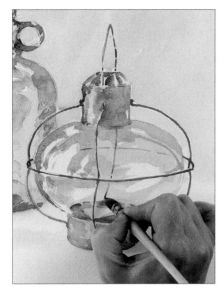

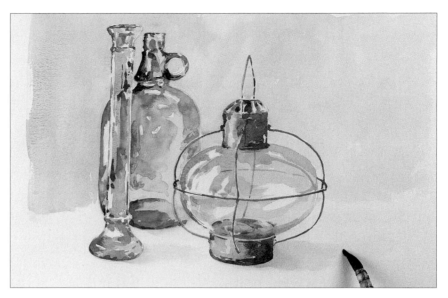

12. Use a watered-down version of the same mix for the wire on the other side of the lamp glass.

13. Use burnt umber and ultramarine for the shadows on the right-hand side of the lamp metal. Mix a pale wash of light red for the candle in the base of the lamp. Use a light wash of burnt umber and ultramarine for the shadow on the right-hand side of the lamp base.

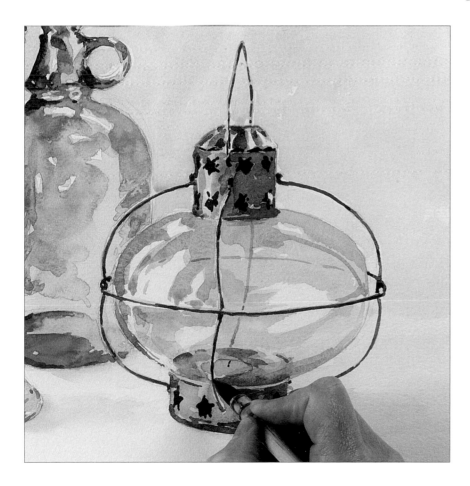

14. For the final darks on the metal, and the star-shaped holes, use a dark mix of ultramarine and burnt umber.

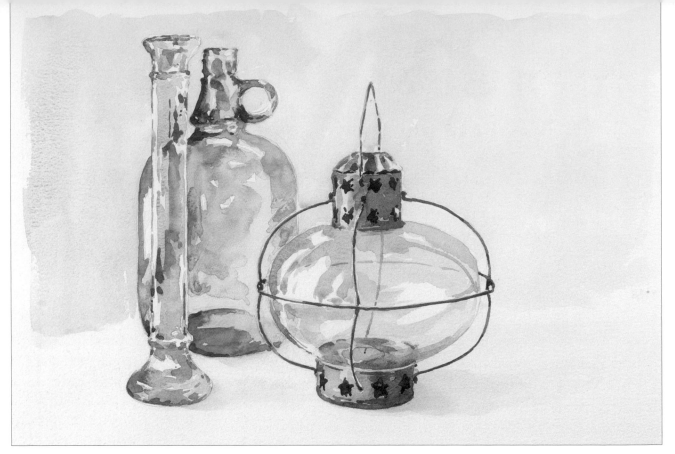

The finished painting

450 x 300mm (17¾ x 11¾in)

This shows the importance of leaving the highlights unpainted right from the start.
When painting glass, what you leave out can be just as important as what you put in.

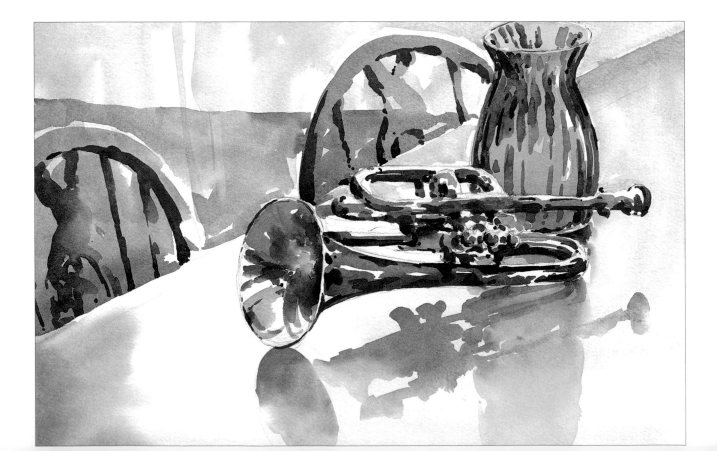

Glass and Sunlight
312 x 400mm (12½ x 15¾in)

I came into the kitchen one morning and saw this wonderful, sunny light hitting the surface of the worktop and pasta jar. I added the large, round green bottle along with the bowl and tea towel. I then set up my easel in the doorway and sketched the arrangement in pencil. I had to paint the objects as quickly as possible as the sun moved rapidly along the worktop.

Opposite

Cornet and Vase
394 x 255mm (15½ x 10in)

This cornet belongs to my dad and I had wanted to paint it for some time. I eventually decided on a backlit view. The usually dark table took on a mirror-like quality and provided some attractive reflections. I placed the vase in the composition to introduce a little colour into what was an otherwise monotone scene. I then painted it very quickly without labouring over fine details.

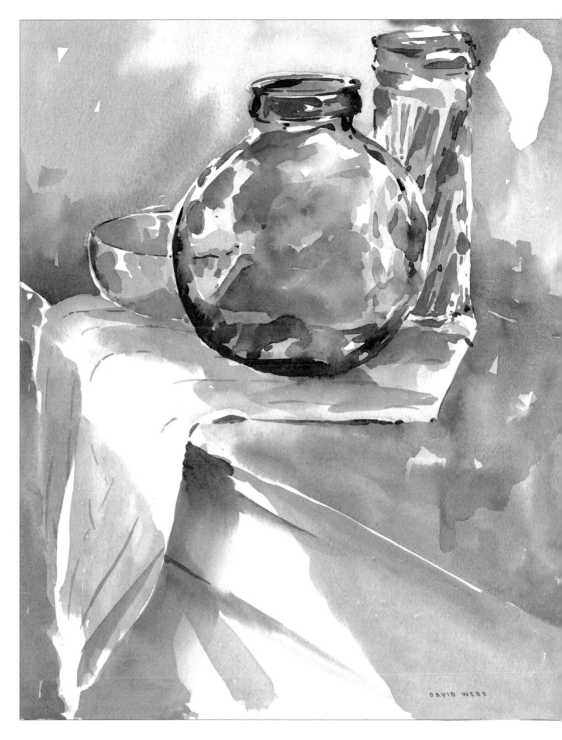

DAVID WEBB

Index

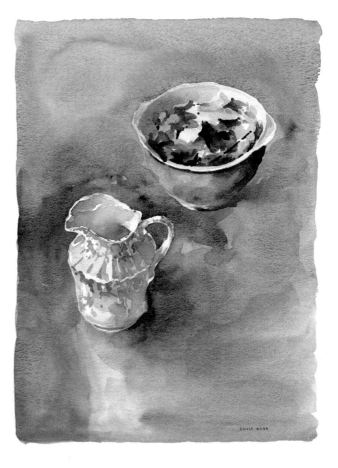

Milk Jug and Pot Pourri
255 x 360mm (10 x 14¼in)
An overcast day provided me
with some soft lighting in
which I could paint this
delicate milk jug. The gentle
pastel colours of the pot pourri
provided some background
interest. Notice how little white
is actually visible on this
'white' jug. As usual I used the
unpainted paper for
the highlights.